Anne Goldthwaite
1869-1944

Anne Goldthwaite
1869-1944

March 22 through May 1, 1977

Montgomery Museum of Fine Arts
Montgomery, Alabama

4

Cover: *The Black Hat*
 Courtesy of the Graham Gallery

Published in conjunction with an exhibition jointly sponsored by a grant from the Alabama State Council on the Arts and Humanities and the National Endowment for the Arts, Washington, D.C., a federal agency.

Copyright © 1977 by Montgomery Museum of Fine Arts
All rights reserved
Library of Congress Catalog Card Number: 77-74790
ISBN: 0-89280-006-2
Design: Lou and Julie Toffaletti, Montgomery, Alabama
Type: Egizio, set by Compos-It, Incorporated, Montgomery, Alabama
Printing: Walker Printing, Incorporated, Montgomery, Alabama

Montgomery Museum of Fine Arts
440 South McDonough Street
Montgomery, Alabama 36104
(205) 834-3490

Printed in the United States

Table of Contents

Lenders to the Exhibition

William Arrington
Montgomery, Alabama

Mrs. Adelyn D. Breeskin
Washington, D.C.

Columbus Gallery of Fine Arts
Columbus, Ohio

Fine Arts Gallery of San Diego
San Diego, California

Lucy Goldthwaite
New York, New York

Richard Goldthwaite
Tampa, Florida

Graham Gallery
New York, New York

Indianapolis Museum of Art
Indianapolis, Indiana

Los Angeles County Museum of Art
Los Angeles, California

Museum of The City of New York
New York, New York

Museum of Fine Arts
Boston, Massachusetts

National Collection of Fine Arts
Washington, D.C.

Mr. and Mrs. John H. Neill
Montgomery, Alabama

The Newark Museum
Newark, New Jersey

Seattle Art Museum
Seattle, Washington

Robert D. Thorington
Montgomery, Alabama

The Toledo Museum of Art
Toledo, Ohio

University of Georgia
Georgia Museum of Art
Athens, Georgia

Whitney Museum of American Art
New York, New York

Acknowledgments

It has been a decade since M. Knoedler and Company organized the last exhibition of the work of Anne Goldthwaite. Miss Goldthwaite was a Montgomery artist whose style is best remembered by her sensitive portrayal of life in the deep South. She was an exhibitor in the Armory Show of 1913 and was very successful in New York with reviews appearing in *The New York Times* as early as 1915. Throughout the 20s, 30s, and 40s, she was an active exhibitor, and taught at the Art Students League in New York until her death in 1944. She is presently represented by Graham Gallery.

The largest body of works assembled to date have been brought together for this exhibition which is divided into two sections—graphics and paintings. We are honored that Mrs. Adelyn D. Breeskin, Consultant with the National Collection of Fine Arts, has written the introduction to the catalog which sensitively probes the dedication and inspiration of this important regional artist. Mrs. Breeskin knew the artist well when they both lived in the East.

Miss Lucy Goldthwaite, the artist's niece, has been extremely helpful in our locating important works and we are indebted to her for her cooperation. Richard Goldthwaite, the artist's nephew and a long time friend of the Museum, loaned us fine examples from his collection for this show. Although the Montgomery Museum has significant holdings of the work of Anne Goldthwaite, we have elected to present a nucleus of paintings largely selected from major museums and collections throughout the country for the current exhibition. We are very grateful to all who have lent works and especially the trustees and staff of the museums represented. A list may be found on the preceding page. The graphic section of the exhibition is from the private collection of Mrs. Adelyn D. Breeskin.

Several members of the Montgomery Museum staff have energetically undertaken the task of the organization of the show. I would like to thank Diane Gingold, Curator; Barbara J. Redjinski, Registrar; and Aleen Moulds, Curatorial Assistant for their contribution in assembling the exhibition.

Henry Flood Robert, Jr.
Director

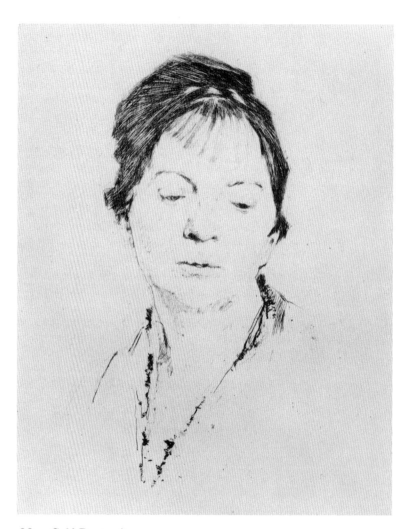

28. *Self Portrait*

Anne Goldthwaite

As long ago as March 22, 1934, Anne Goldthwaite spoke on the radio in support of women artists. She then announced that women had at last found a spokesman in the distinguished critic Mr. Forbes Watson who wrote an article in *The Brooklyn Eagle* entitled "Vicissitudes of Women in Art." However, Anne Goldthwaite, appreciative as she was of his support, preferred to approach the subject from a different angle. She said "I know that in ancient times Venus de Milo was matched by the Apollo Belvedere. In the Middle Ages the preeminence of The Blessed Virgin owed something to artists who loved to depict what they most admired—women. And now one sees in current exhibitions with what the artists of today are preoccupied—a few with landscapes, a few with flowers, a *very* few with portraits of men, but all the rest focus on women. In exhibitions where women shine as subject matter they are gradually acquiring glory as artists as well. If this ascendency continues it will be great for women, since nobody's art can flourish unless it gains appreciation. The best praise that women have been able to command until now is to have it said that she paints like a man. But that women have a valid place as women artists is both obvious and logical. Art is an escape from the sorrows of life—it is a hint of happiness and to give happiness has surely been the traditional role of women since history began. Women have the thirst for self-expression and so they have entered the field of Art." She insisted that "we want freedom to express beauty as we feel it and wherever we find it. And we want more—we want to speak to eyes and ears wide open and without prejudice—an audience that asks simply—is it good, not—was it done by a woman."

This radio talk, given over forty years ago by this strong adherent of women's rights, can alert us to the fact that she was an American artist of rare insight and power who was in many ways ahead of her time. She was born in 1869 in Montgomery, Alabama, the daughter of a dashing artillery captain in a Confederate battery in The War Between The States. Her grandfather, George Goldthwaite, was descended from an old Boston family (whose portraits were painted by Feke and Copley). He equipped The Alabama Troops in the War, was Justice of the State Supreme Court and the first Southern Senator to go back to Washington after the Reconstruction. Anne lived in Montgomery. She was happy there since she remembered her life as being filled with love, warmth,

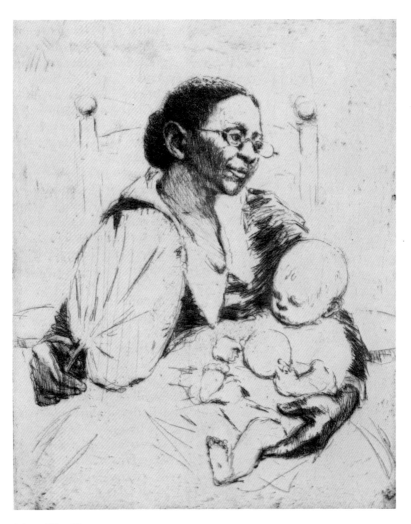

36. *His Mammy*

ease and approbation. Her Mammy was of tremendous importance to her and as Anne has written: "I was of equal importance to Mammy. She was inordinately proud of my good looks and my bad temper, especially the latter. In a group of other nurses with their charges I have heard her boast of my misdeeds—how in a stiff rage, I slipped from my high chair when they put cream on my peaches without my consent."

Continuing her reminiscences Anne wrote: "In the South after the Civil War it was a disgrace to be rich, so my grandfather could not have had much money. In homes such as I knew, one found beautiful silver and broken china, worn carpets and great cracked mirrors, the best cooks and much leisure, beautiful old books but no money for new ones. Men were then without hope of a better future. Consequently, my father, being young and adventurous, decided to seek his fortune in Texas where my grandfather owned plantations. One day, a year after my father left us to find a home in Dallas, we followed him—my mother, my brother, my Mammy and I. My mother was an Armistead from Virginia, all noted for their wit and perhaps she was the wittiest of all of them." It was a trait which Anne certainly inherited. Her early education was in a Texas "young ladies' school" conducted by a Mrs. Coughanour who "held the very advanced theory that if all little girls knew only love and were given everything they wanted they would all be good." Later she attended an Ursuline Nun's Convent school. But then both of her parents died and the family sent for the four children to come back to Alabama where each of them was placed in the care of a different relative, Anne going to her Aunt Molly Arrington who already had a big family of six sons and three daughters. She grew up there and at eighteen came out with a reception and dance just as her older cousin, Olivia had done. Her Aunt Molly's favorite quotation was "Gather ye rosebuds while ye may" and matrimony was considered the desired end. But Anne took to art as a serious career instead.

It was about 1898 when her Uncle Henry Goldthwaite came for a visit and took her with him when he returned to New York, promising to pay her expenses for eight or ten years since he thought her art training would take that long. On the way to New York he gave the following advice. There were cardinal points to remember, he said: "One was never to leave the house with my gloves unbuttoned, never to carry more than two dollars in my

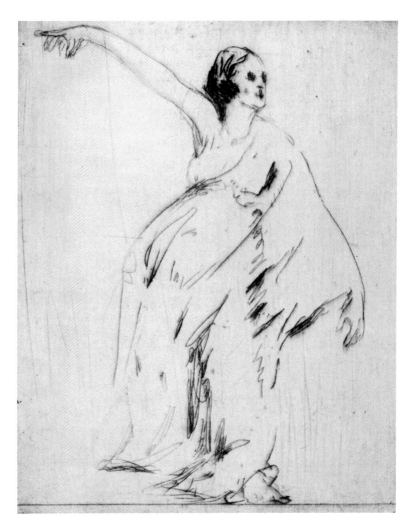

25. *Isadora Duncan Dancing to the Marseillaise*

purse and never to go out with any man, no matter where or why." So later, if a fellow student at the National Academy of Design where she studied asked her to see an exhibition with him, which was for all of the students an everyday occurrence, she would meet him there but not walk along the street with him, but this could not continue for long. She then studied with Walter Shirlaw for whom she retained much admiration throughout her life. She studied hard and progressed splendidly or as she said, "as well as anyone else." During her six or more years at the Academy she had other instructors including Charles F.W. Mielatz and Francis Jones and finally took the necessary step, then regarded as essential, of continuing her education in Paris.

After a brief trip to Germany she arrived in 1906 and went at once to Mrs. Whitelaw-Reid's Club for American Girls in the rue de Chevreuse. It was a charming, very old house built around a wide courtyard, inviting in every respect. It was filled with very interesting young women, among them Frances Thomason who soon introduced her to Gertrude Stein. As Anne tells the story: "Miss Thomason called to me as we were sketching in the Luxembourg Gardens to meet a large, dark woman with whom she was talking who looked something like an immense dark brown egg. She wore, wrapped tight around her, a brown kimona-like garment and a large flat black hat and stood on feet covered with wide sandals. 'Miss Stein wants us to go home with her for tea,' said Miss Thomason. Looking at the dark brown woman I wondered whether we ought to accept the invitation, whether she could afford to divide her tea with us. We did not have far to go to the rue Fleurus, and as we walked past the concierges cage Miss Stein ordered tea to be served for three. Crossing a little pebbled court we went into a beautiful large studio filled with antique Italian furniture. The walls were covered with the most remarkable pictures I had ever seen. Before we sat down Miss Stein and Miss Thomason asked me what I thought of them and I walked up and down trying to decide what to say.—As tea was soon brought in I did not have to answer. We had tea and the most delightful conversation. Miss Stein spoke of her writing and whenever painting was mentioned she would say 'I know nothing about it; I only quote my brothers—(Mike and Leo).' I have been back to Gertrude Stein's studio many times since but I have never again found her in the mood of that afternoon."

As Anne's Paris years passed she participated in the mild Victorian bohemianism of Montparnasse, but also saw Diaghilev's Russian Ballet, saw Nijinsky dance as well as Isadora Duncan, heard Harold Bauer's concerts and made many good friends. Among them was David Rosen who had a class made up mostly of American women whom he conducted during more than one summer to Ile-aux-Moines in the Oise country on sketching trips.

Another good friend was Elizabeth Duncan, Isadora's sister, through whom she met the many dancers whom she sketched in all of twenty-three different etchings and drypoints. With David Rosen's help she became one of the organizers of the Académie Moderne. A small group of young artists agreed to meet regularly asking Charles Guérin to serve as critic of their efforts. They held an exhibition each spring and then the best of the work would be shown at the Autumn Salon. Guérin's friends and colleagues—Pierre Laprade, Albert Marquet and Othon Friesz came from time to time to air their views. And so the years passed—seven altogether before the threat of World War I drove Anne home in 1913. Her reactions to the change in atmosphere for an artist are of interest. She has written: "The life of an artist in New York is not unpleasant barring the inevitable anxiety as to whether one has talent and if so what can one do with it; how can one reach a public; how can one live. I found that the great difference between the life of an art student here and in Paris is that in New York nobody is conscious of the fact that such individuals exist, nobody thinks of them as a class; each student is seen as a strange person who happened to go astray in a labyrinth called art. In Paris, on the other hand, they are a class whose existence is acknowledged as important and scarcely abnormal." Therefore upon returning to New York important adjustments are necessary.

During that very year of 1913 The Armory Show took place and Anne entered a painting in it and since she already had earned the reputation of being a remarkable portrait painter she fared well. Her friend Mrs. Harold Bauer brought Katherine Dreier to see her and an invitation soon followed to Miss Dreier's place in Redding, Connecticut, but first she went to Saranac Lake to paint a portrait of Miss Dreier's sister Dorothea. Then two years later, Katherine sat for her portrait also. Anne's easy, outgoing nature and her lack of all pretence brought her many friends in the art world and her art prospered. In all

of her work she achieved that rare quality called style and regardless of the years spent away from her native Alabama she evoked the very spirit of the South. I know of no other artist of her time or since then who has so vividly and sensitively portrayed the glittering bayous, the hot, sunny fields and the shanties of the black people whom she loved. She painted them with a clear, true vision, with a vigor of touch and a spontaneity of handling rarely found in the work of her associates—either men or women.

After setting up her studio home first on West 12th Street in New York, later moving to East 10th Street, she spent almost every summer in Montgomery with her family. There she belonged and much of her best work in both painting and printmaking reflects her feeling for the rhythms, the harmonies, the local color of that special part of America. She felt entirely at home there and increased the scope of her work to include sculpture as well as painting and prints. Around Montgomery she found an old deserted brick kiln. From it she took clay and with it made a number of very characterful small negro heads measuring about six inches in height and a few small seated figures as well. These she glazed so that they resemble brown bronze and are quite durable. The three-dimensional studies helped her to perfect her portrait work but she is best known for her charming figure compositions of women and children and for landscapes and genre studies of her native Alabama. No one could record better than she the blazing sun on a broiling summer day.

In 1915 she won national recognition with the McMillan landscape prize by the National Association of Women Painters and Sculptors and a bronze medal for an etching at the Pan-Pacific Exposition in San Francisco. Ever since she has been recognized as one of the leading painters of the South. In 1922 she became a member of the teaching staff of The Art Students League and continued her teaching there until just before her death in 1945. She painted murals in the Post Offices of Atmore and Tuskegee, Alabama for The Section of Fine Art of the Federal Works Agency. She was for many years active in the American Printmakers group and was more than once its chairperson. I know of no other American who produced as much excellent graphic work spread over as many years. Her etchings, drypoints and lithographs number over two hundred subjects. They were produced between the last years of the 19th century and the year of

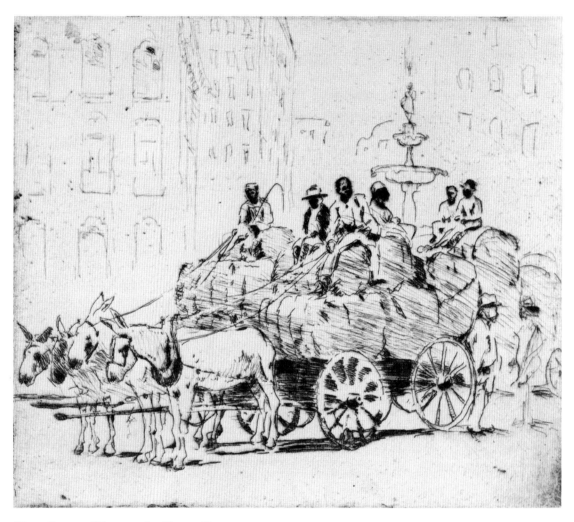

32. *Cotton Wagons in Court Square*

her death. Throughout they show a consistency and an individuality which mark them as her very own. Her technique is free and firm, allowing plenty of scope for the full expression of her vision. Most of her portrait etchings are informal sketches of friends and acquaintances, people whom she enjoyed knowing, recording their likenesses as she conversed with them, even in the case of Cardinal Gibbons and some other prelates. Showing off her delightful wit, inherited from her mother, is the drypoint sketch of William Butler Yeats drawing the portrait of a lovely young girl. At her most eloquent we find her treating Negro subjects such as *Saturday* and *Cotton Wagons on Court Square.* It was while teaching at the League that she mastered the art of lithography and added to the most vivid and meaningful of these records of the Southern Black people, such subjects as *Waterhole* and *Pool Room.*

In summing up her contribution to the art of her time during the first forty years of this century, I believe that she forged a broad and a deep groove in the art of her time. Her friend Harry B. Wehle, for many years the Curator of Painting at the Metropolitan Museum of Art in New York, has written that "From almost everything she drew or painted there emanates a breath of wit, not mere whimsy but a wiser sort of gaiety which looks with more tolerance into the hearts of her sitters whether they be judges, ministers, little girls, trees, flowers or Alabama Negroes. She knew them all and delighted in them and much of her delicate humor in depicting them is actually a function of her pungent, insouciant, elusive way of painting."

With unfailing draftsmanship and deft painting she excelled and we, her friends who enjoyed her during her lifetime, are delighted that she is being given this memorial exhibition to revive her individual personality which radiates from her work with glowing assertiveness.

Adelyn D. Breeskin
Consultant
20th Century Painting and Sculpture Department
National Collection of Fine Arts

Graphics

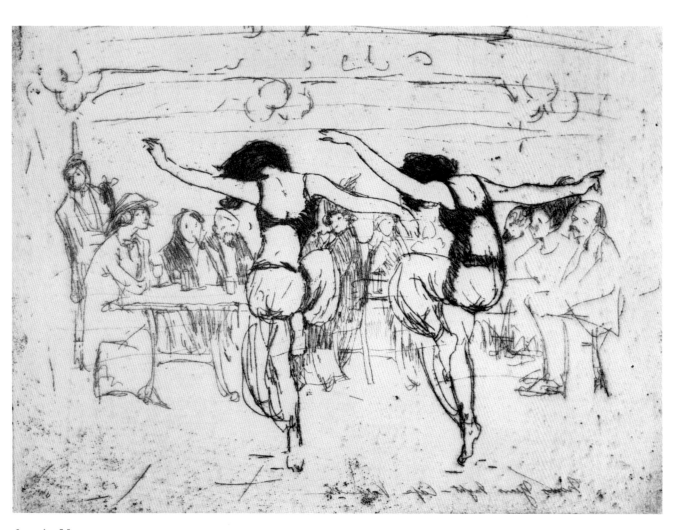

6.　*At Montmartre*

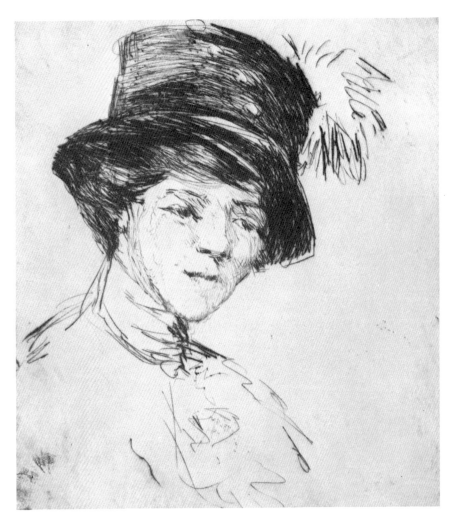

15. *Lucille in Paris*

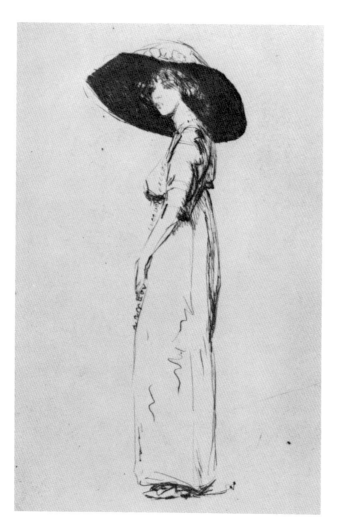

16. *Mademoiselle*

24

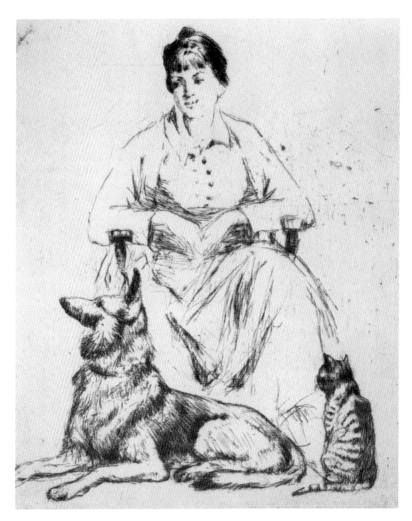

26. *Anne with Major and Minnie III*

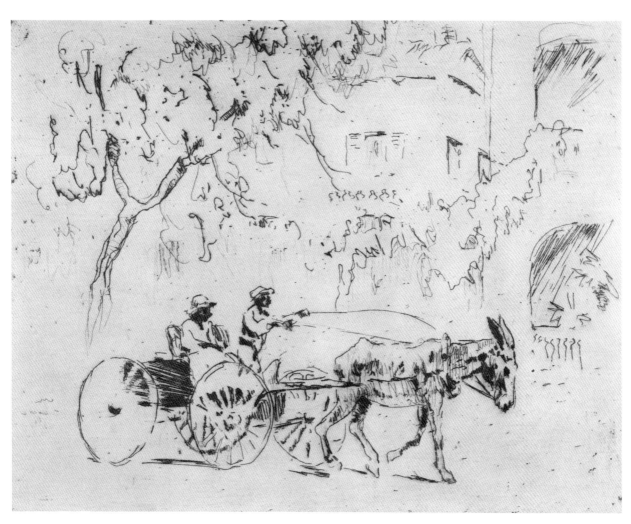

29. *Saturday (in Alabama)*

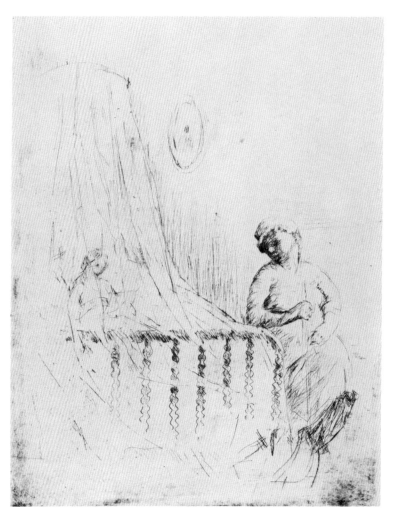

35. *The Mosquito Net*

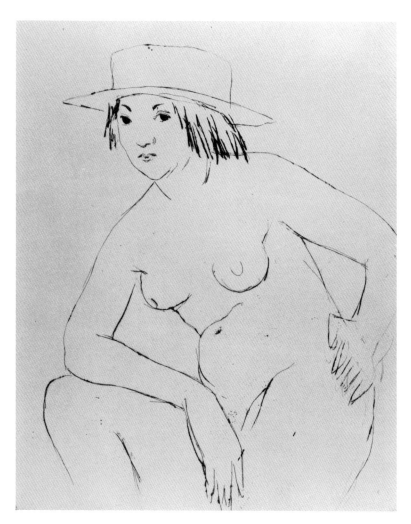

41. *Nude with Hat*

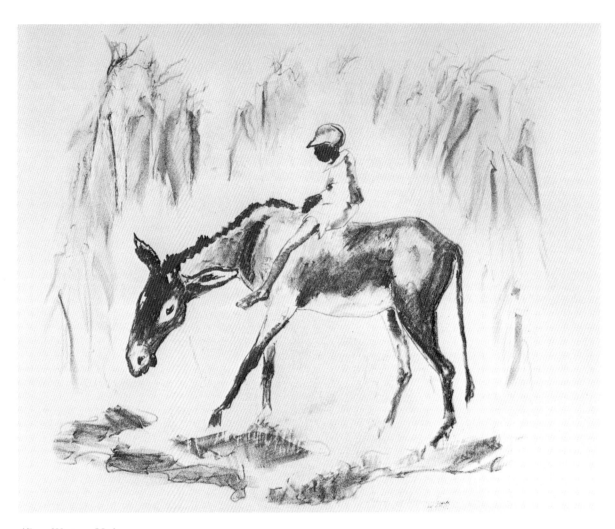

45. *Water Hole*

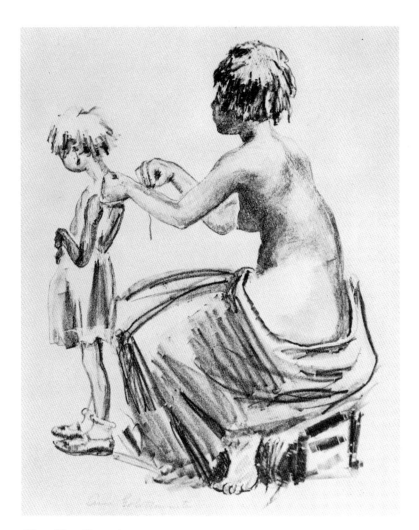

50. *Her Daughter*

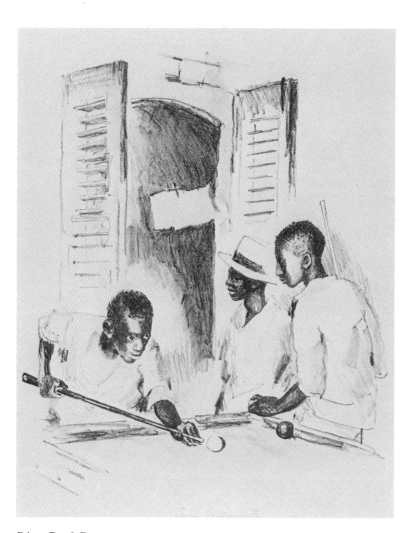

54. *Pool Room*

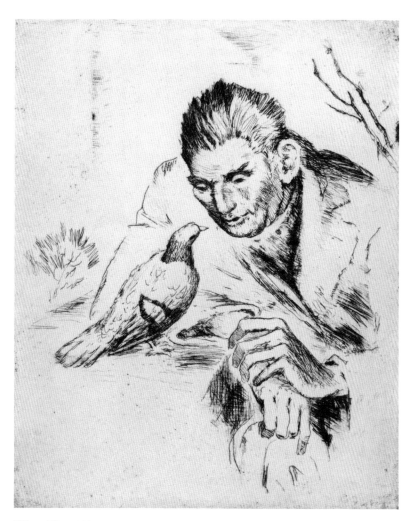

57. *The Visitor*

Dimensions are given in inches.
Height precedes width.
Illustrated works are noted by an asterisk (*).

Graphics Catalog

1. *American Indian Model in Class,* c. 1903
 Etching, only known state
 11 7/8 x 8 7/8

2. *October in France,* c. 1907
 Etching, only known state
 4 1/8 x 3 1/2

 Exhibitions: Berlin Photographic Co., New York, 1915; Portland
 Art Association, Oregon, February, 1916; Syracuse
 Museum, March, 1924

3. *St. Sulpice, Paris,* 1908
 Etching, only known state
 7 7/8 x 6 1/4

4. *Gates to the Luxembourg Gardens,* 1908
 Etching, only known state
 5 5/8 x 6 7/8

 Exhibitions: Berlin Photographic Co., New York, 1915;
 Brummer Gallery, New York, October, 1921

5. *The Letter* (Miss Walker), c. 1908
 Etching, only known state
 4 x 3 3/8

 Exhibitions: Berlin Photographic Co., New York, 1915; Portland
 Art Association, Oregon, February, 1916; Syracuse
 Museum, March, 1924; Korner and Wood Co.,
 Cleveland, June, 1942

6. *At Montmartre,* 1910 *
 Etching, only known state
 5 13/16 x 7 13/16

 Exhibitions: Berlin Photographic Co., New York, 1915; Portland
 Art Association, Oregon, February, 1916; Brummer
 Gallery, New York, October, 1921; Syracuse
 Museum, March, 1924; Korner and Wood Co.,
 Cleveland, June, 1942; M. Knoedler and Co., New
 York, Memorial Exhibition, 1944

7. *Les Sylphides* (Russian Dancers), 1910
 Drypoint, only known state
 6 7/16 x 8 7/16

 Exhibitions: Brummer Gallery, New York, October, 1921

8. *Nijinsky,* 1911
 Etching, only known state
 6 7/16 x 4 1/8

 Exhibitions: Berlin Photographic Co., New York, 1915; Portland
 Art Association, Oregon, February, 1916

9. *Moment Musical I,* 1911
 Drypoint, third state of three
 8 3/8 x 7 1/8

 Exhibitions: Berlin Photographic Co., New York, 1915; Portland
 Art Association, Oregon, February, 1916; Brummer
 Gallery, New York, October, 1921; Syracuse
 Museum, March, 1924; Korner and Wood Co.,
 Cleveland, June, 1942

10. *The Moth,* 1911
 Etchings and drypoint, second state
 9 3/4 x 7 13/16

 Exhibitions: Brummer Gallery, New York, October, 1942;
 Korner and Wood Co., Cleveland, June, 1942

11. *Chateau Thierry Station,* 1911
 Etching, only known state
 5 3/4 x 7 1/4

 Exhibitions: Syracuse Museum, March, 1924

12. *The Storm: Grez-sur-Loing,* c. 1911
 Etching, only known state
 7 x 9 3/8

13. *Sunny Hillside, France,* 1912
 Etching, only known state
 6 1/4 x 7

 Exhibitions: Berlin Photographic Co., New York, 1915; Portland
 Art Association, Oregon, February, 1916; Brummer
 Gallery, New York, October, 1921

14. *Bébé van Knapitsch,* c. 1912
 Drypoint, second state of two
 7 x 6 1/4
 In Collection of The Library of Congress

 Exhibitions: Portland Art Association, Oregon, February, 1916;
 Brummer Gallery, New York, October, 1921;
 Syracuse Museum, March, 1924; Korner and Wood
 Co., Cleveland, June, 1924; M. Knoedler and Co.,
 New York, Memorial Exhibition, 1944

15. *Lucille in Paris,* 1912 *
 Etching and drypoint, second state of two
 7 x 6 3/8

16. *Mademoiselle,* c. 1912 *
 Etching and drypoint, only known state
 8 5/8 x 5 1/2

17. *Still Life with Flowers,* 1913
 Aquatint and etching, only known state
 13 3/4 x 17 1/2

18. *Cock Fight,* c. 1913
Etching, only known state
$4\,{}^1/_{16}$ x $6\,{}^7/_{16}$
Published in Colophon, Pynson Printers

Exhibitions: Berlin Photographic Co., New York, 1915; Portland
Art Association, Oregon, February, 1916; Brummer
Gallery, New York, October, 1921; Syracuse
Museum, March, 1924

19. *Woodrow Wilson* (from the sidewalk), 1913 or 1914
Etching, only known state
$9\,{}^3/_4$ x $7\,{}^3/_4$

Exhibitions: Korner and Wood Co., Cleveland, June, 1942; M.
Knoedler and Co., New York, Memorial Exhibition,
1944

20. *Roy Frank,* c. 1913
Color aquatint, only known state
$6\,{}^7/_8$ x 5

21. *Harold Bauer II,* 1915
Etching, fourth state of four
$9\,{}^3/_4$ x $7\,{}^3/_4$
Published in Fine Prints of the Year, 1928 (page 73)

Exhibitions: Syracuse Museum, March, 1924; The Corcoran
Gallery, Washington, D.C., December, 1939-June,
1940; Korner and Wood Co., Cleveland, June, 1942;
M. Knoedler and Co., New York, Memorial
Exhibition, 1944

22. *Southern Pines,* 1915
Etching, third state of three
$5\,{}^7/_8$ x 7

Exhibitions: Berlin Photographic Co., New York, 1915 entitled
"Alabama;" Portland Art Association, Oregon,
February, 1916; Syracuse Museum, March, 1924

23. *Cardinal Gibbons I,* c. 1915
Etching, third state of three
$9\,{}^3/_4$ x $6\,{}^3/_8$

24. *Portrait of Katherine Dreier IV,* 1916
Drypoint, third state of three
$8\,{}^7/_8$ x $6\,{}^7/_8$

25. *Isadora Duncan Dancing to "Le Marseillaise,"* 1916
Etching, only known state
$7\,{}^3/_4$ x $6\,{}^1/_8$

Exhibitions: Portland Art Association, Oregon, February, 1916

26. *Anne with Major and Minnie III*, c. 1916 *
Etching, second state of two
9 3/4 x 7 3/4

27. *Lady Chapel: Church of St. Mary, The Virgin*, 1918
Etching and drypoint, second state of two
6 7/8 x 5 7/8

28. *Self Portrait*, c. 1918
Etching, second state of two
9 7/8 x 7 7/8

 Exhibitions: Bibliothèque Nationale, Paris, July, 1918; M.
 Knoedler and Co., New York, Memorial Exhibition,
 1944

29. *Saturday* (in Alabama), c. 1920 *
Etching, only known state
7 x 8 3/4

 Exhibitions: Brummer Gallery, New York, October, 1921;
 Syracuse Museum, March, 1924; Chicago
 International Exhibition of Etchings, 1924; Korner
 and Wood Co., Cleveland, June, 1924; M. Knoedler
 and Co., New York, Memorial Exhibition, 1944

30. *Negro Women at a Fountain*, c. 1920
Etching, only known state
6 x 6 3/4

 Exhibitions: Brummer Gallery, New York, October, 1921

31. *Boquehomme*, c. 1920
Etching, only known state
6 1/4 x 7 1/4

 Exhibitions: Downtown Gallery, New York, February, 1929

32. *Cotton Wagons in Court Square*, c. 1920
Etching, second state of two
5 7/8 x 6 7/8

 Exhibitions: Brummer Gallery, New York, October, 1921;
 Syracuse Museum, March, 1924; M. Knoedler and
 Co., New York, Memorial Exhibition, 1944

33. *Carnival*, 1921
Etching and drypoint, second state of two
6 3/8 x 8 1/4

 Exhibitions: Brummer Gallery, New York, October, 1921

34. *Mr. Yeats Drawing the Portrait of a Young Lady*, 1922
Drypoint, only known state
9 13/16 x 7 3/4

 Exhibitions: M. Knoedler and Co., New York, Memorial
 Exhibition, 1944

35. *The Mosquito Net,* 1923 *
 Etching and drypoint, second state of two
 7 3/4 x 6

 Exhibitions: Downtown Gallery, New York, October-November,
 1929

36. *His Mammy,* c. 1923
 Etching and drypoint, second state of two
 8 13/16 x 6 7/8

37. *East Tenth Street* (Anne at the Window), 1928
 Etching, second state of two
 9 7/8 x 7 7/8
 Published in *Fine Prints of the Year,* 1931 (page 72)

 Exhibitions: M. Knoedler and Co., New York, Memorial
 Exhibition, 1944

38. *Cock and Hen,* 1928
 Etching, hand colored, only known state
 4 11/16 x 5 7/8

39. *Mother and Child on a Couch,* c. 1928
 Drypoint, only known state
 8 3/8 x 10 3/8

 Exhibitions: Downtown Gallery, New York, October-
 November, 1929

40. *Coiffeuse,* c. 1929
 Drypoint, second state of two
 6 7/8 x 5 7/8

 Exhibitions: Downtown Gallery, New York, October-
 November, 1930

41. *Nude with Hat,* c. 1929 *
 Drypoint, second state of two
 9 7/8 x 7 7/8

 Exhibitions: Korner and Wood Co., Cleveland, June, 1942; M.
 Knoedler and Co., New York, Memorial Exhibition,
 1944

42. *Heron Rising Over the Alabama,* 1929
 Etching, only known state
 4 15/16 x 5 15/16
 Published in an edition of fifty

43. *Pigeons*, c. 1929
 Lithograph, only known state
 11 1/4 x 15 3/4 (page size)
 Published in an edition of fifty

 Exhibitions: Downtown Gallery, New York, December, 1929;
 Korner and Wood Co., Cleveland, June, 1942; M.
 Knoedler and Co., New York, Memorial Exhibition,
 1944

44. *Horse and Rider*, 1931
 Lithograph, only known state
 9 1/2 x 10 (stone)
 Published in an edition of possibly fifty
 Published in *Fine Prints of the Year*, 1932

 Exhibitions: Korner and Wood Co., Cleveland, June, 1942

45. *Waterhole*, 1931 *
 Lithograph, only known state
 9 1/2 x 11
 Published in an edition of fifty

 Exhibitions: American Printmakers, 1932 (with illustration);
 Korner and Wood Co., Cleveland, June, 1942; M.
 Knoedler and Co., New York, Memorial Exhibition,
 1944

46. *Corner Pocket*, 1931
 Etching, only known state
 7 3/4 x 9 7/8

47. *Mending II*, 1931
 Lithograph, first state of three
 7 1/2 x 9 1/2

 Exhibitions: American Printmakers Ninth Annual, December,
 1934; Downtown Gallery, New York, March, 1936;
 Korner and Wood Co., Cleveland, June, 1942; M.
 Knoedler and Co., New York, Memorial Exhibition,
 1944

48. *Selma*, 1933
 Lithograph, fourth state of four
 15 3/4 x 11 3/16 (page size)
 Published in an edition of possibly fifty

49. *Nude Reading*, 1933
 Lithograph, second state of two
 10 3/4 x 9 1/4 (page size)
 Published in an edition of fifty

 Exhibitions: Korner and Wood Co., Cleveland, June, 1942; M.
 Knoedler and Co., New York, Memorial Exhibition,
 1944

50. *Her Daughter,* 1934 *
 Lithograph, only known state
 10 1/4 x 7 1/4
 Published in an edition of possibly twenty-five
 15 3/4 x 11 1/2 (page size)

 Exhibitions: The Corcoran Gallery, Washington, D.C.,
 December, 1939-January, 1940; Korner and Wood
 Co., Cleveland, June, 1942; M. Knoedler and Co.,
 New York, Memorial Exhibition, 1944

51. *Street Fiddler,* 1934
 Lithograph, only known state
 10 1/2 x 7 1/4
 Published in an edition of twenty-five
 15 3/4 x 11 1/2 (page size)

 Exhibitions: American Printmakers Ninth Annual, December,
 1934; Downtown Gallery, New York, October, 1935

52. *Up in the Morning,* c. 1934
 Etching, only known state
 5 7/8 x 7 7/8

 Exhibitions: American Printmakers Ninth Annual, December,
 1934; Downtown Gallery, New York, 1934

53. *Sheep,* 1934
 Etching, only known state
 6 x 4 1/2

 Exhibitions: American Printmakers Ninth Annual, December,
 1934; Downtown Gallery, New York, 1934

54. *Pool Room,* 1935 *
 Lithograph, only known state
 11 x 9 1/2 (stone)
 15 7/8 x 11 1/2 (page size)

 Exhibitions: American Printmakers Tenth Annual, December,
 1935; Korner and Wood Co., Cleveland, June, 1942;
 M. Knoedler and Co., New York, Memorial
 Exhibition, 1944

55. *Young Negress,* 1936
 Lithotint, only known state
 13 x 10 1/8 (page size)
 Published in Alain Locke's *The Negro in Art,* 1940
 Published in an edition of ten numbered prints

 Exhibitions: M. Knoedler and Co., New York, Memorial
 Exhibition, 1944

56. *Mare and Foal,* 1938
Lithograph, only known state
11 3/8 x 16 (page size)
Published in an edition of possibly fifty

Exhibitions: Korner and Wood Co., Cleveland, June, 1942; M.
Knoedler and Co., New York, Memorial Exhibition,
1944

57. *The Visitor,* 1942 *
Etching, second state of two
10 7/8 x 8 7/16

Exhibitions: Korner and Wood Co., Cleveland, June, 1942; M.
Knoedler and Co., New York, Memorial Exhibition,
1944

Paintings

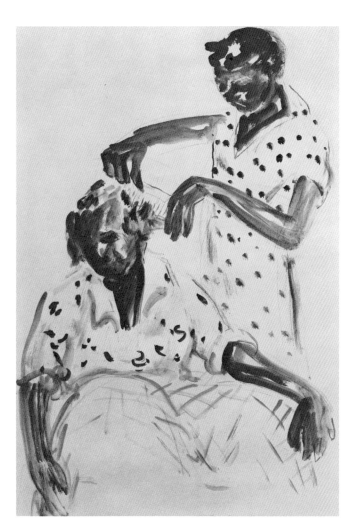

2. *The Coiffeur*
Courtesy of The Newark Museum

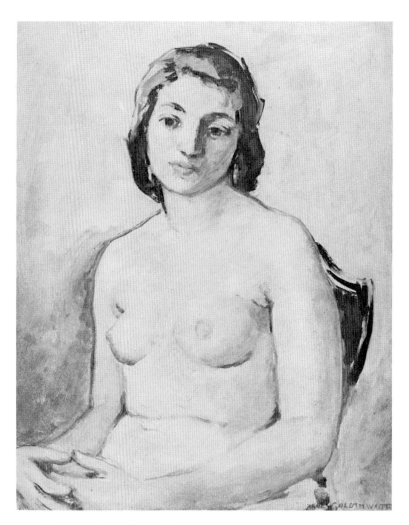

3. *Composition, Nude Figure*
 Courtesy of the Fine Arts Gallery of San Diego

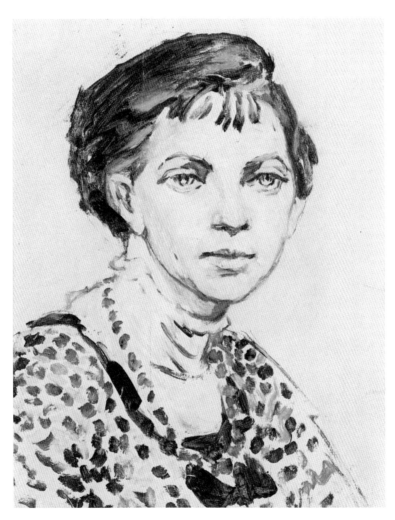

5. *Early Self Portrait*
Courtesy of the National Collection of Fine
Arts

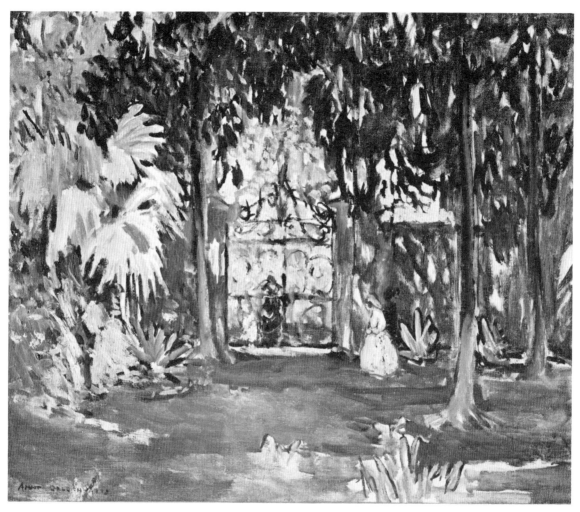

7. *Garden Gate, Near Ascain*
 Courtesy of The Metropolitan Museum of Art

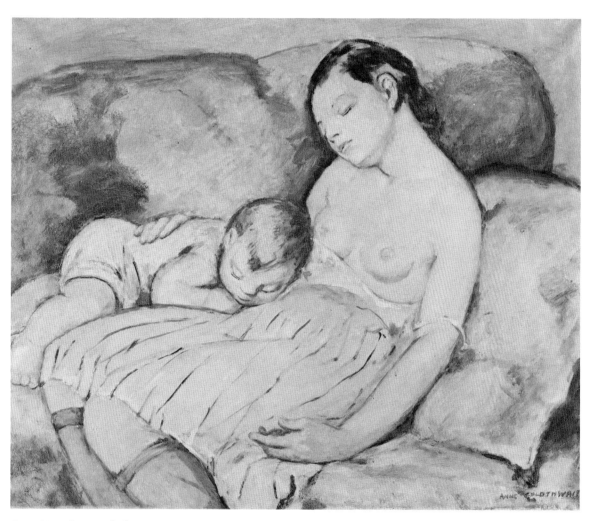

8. *The Green Sofa*
Courtesy of The Metropolitan Museum of Art

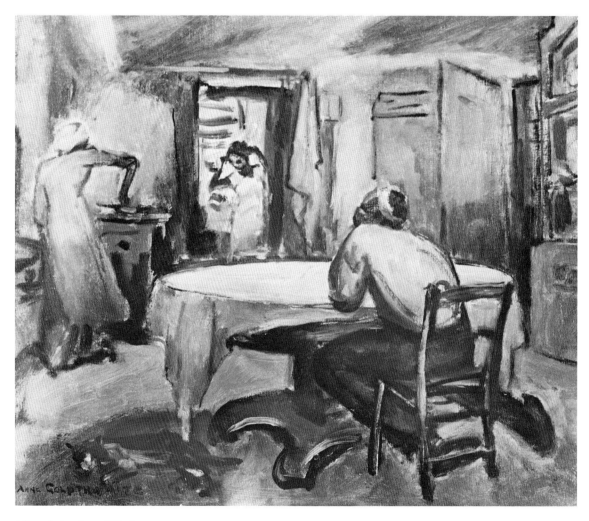

10. *Interior, Kitchen*
 Courtesy of the Seattle Art Museum

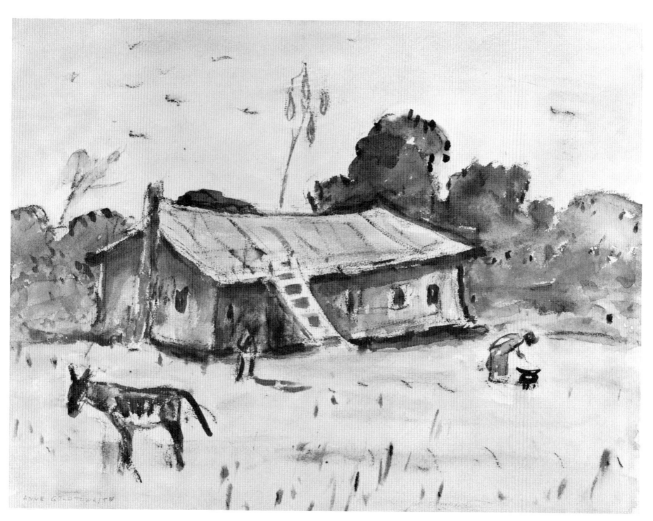

20. *Shanty with Martin's Nest (Cabin in Alabama)*
Courtesy of National Collection of Fine Arts

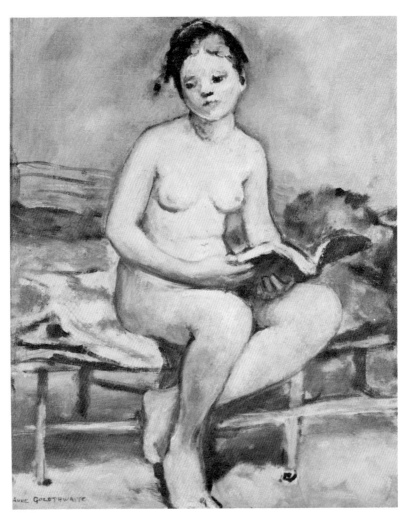

14. *The Nude*
Courtesy of the Montgomery Museum of Fine Arts

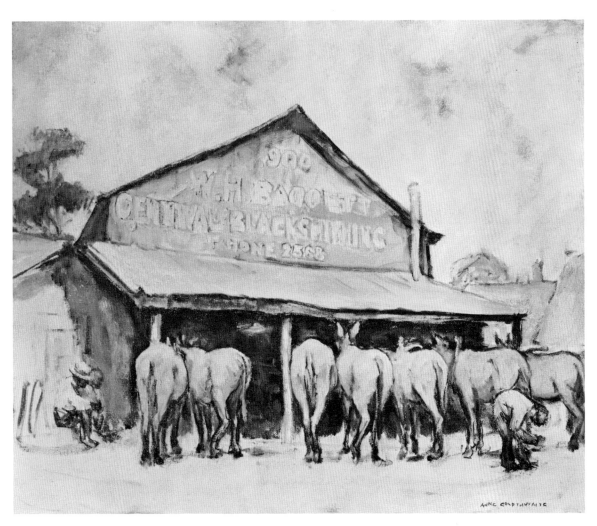

16. *On the Road to Alabama*
 Courtesy of the Museum of Fine Arts, Boston

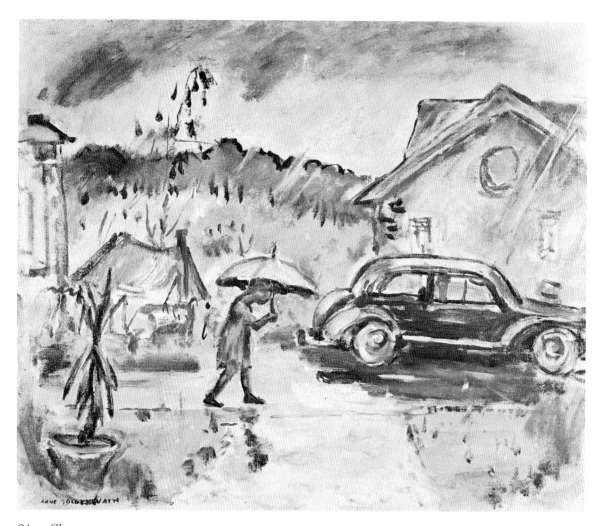

21. *Showers*
 Courtesy of the University of Georgia, Georgia Museum of Art

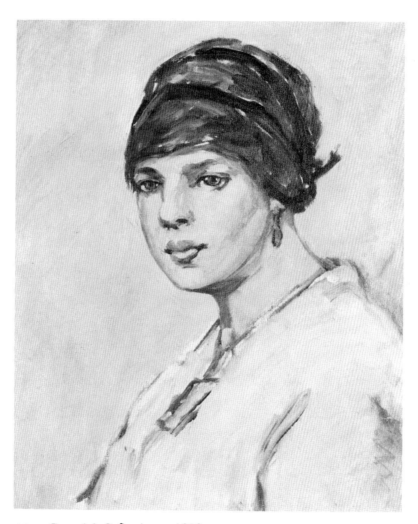

22. *Spanish Señorita,* c. 1912
Courtesy of Mr. and Mrs. John H. Neill

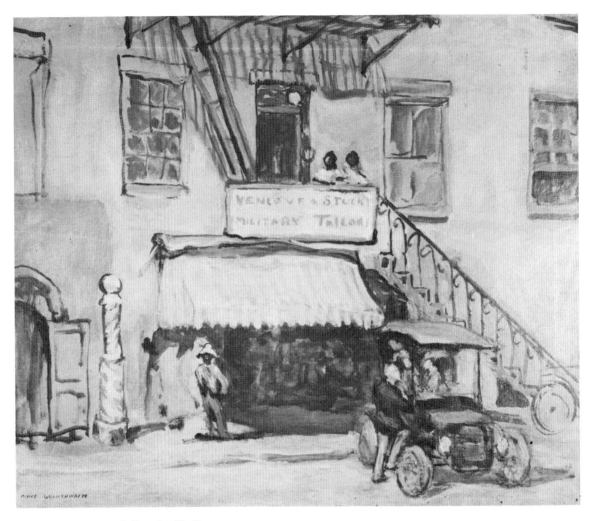

26. *Venlove and Stucky Tailors*
Courtesy of Richard Goldthwaite

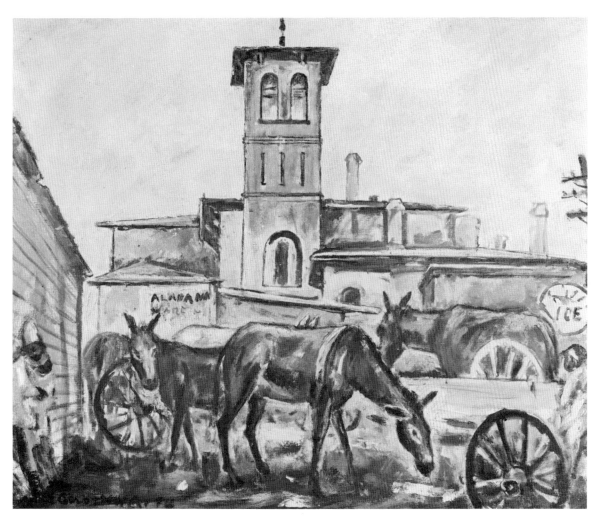

28. *The Wagon Yard*
 Courtesy of the Columbus Gallery of Fine Arts

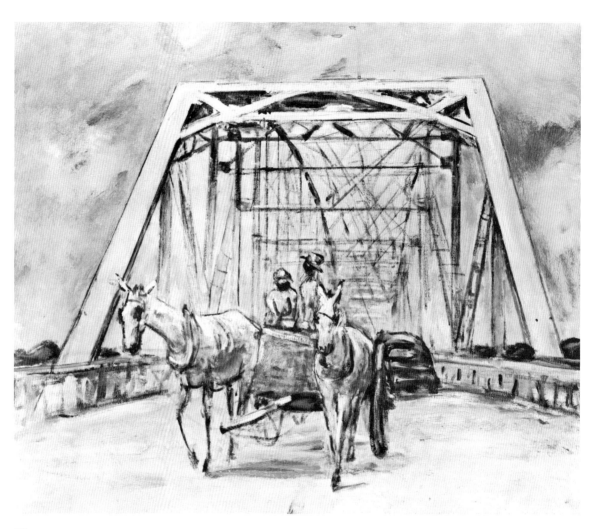

32. *White Mules on a Bridge*
Courtesy of The Metropolitan Museum of Art

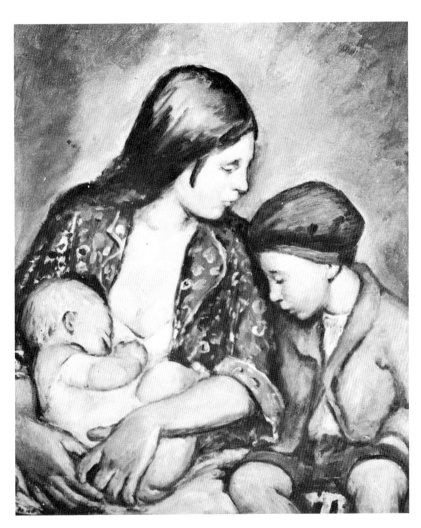

33. *Young Mother*
Courtesy of the Indianapolis Museum of Art

Dimensions are given in inches.
Height precedes width.
Illustrated works are noted by an asterisk (*).

Painting Catalog

1. *The Black Hat**
 Oil on canvas
 21 x 18
 Graham Gallery

 Exhibitions: Kennedy Galleries (and tour), New York, May, 1967

2. *The Coiffeur**
 Watercolor
 24 3/4 x 15 5/8
 The Newark Museum

3. *Composition, Nude Figure**
 Oil on canvas
 29 x 23
 Fine Arts Gallery of San Diego, Gift of Lucy Armistead Goldthwaite

 Exhibitions: Architectural and Allied Arts Exposition, New York, April, 1929; Downtown Gallery, New York, January-February, 1930

4. *Dusty Road*
 Oil on canvas
 15 x 18 1/4
 Lucy Goldthwaite

5. *Early Self Portrait**
 Oil on fiberboard
 15 1/2 x 12 1/4
 National Collection of Fine Arts, Gift of Lucy Goldthwaite and Richard Wallach

6. *4, Rue de Chevreuse,* c. 1908
 Oil on canvas
 29 x 23 3/4
 Whitney Museum of American Art

 Exhibitions: M. Knoedler and Co., New York, Memorial Exhibition, 1944

7. *Garden Gate, Near Ascain**
 Oil on canvas
 22 1/4 x 18
 The Metropolitan Museum of Art

8. *The Green Sofa**
 Oil on canvas
 30 x 36
 The Metropolitan Museum of Art

 Exhibitions: American Society of Painters, Sculptors, Engravers, New York, May, 1939; Georgette Passedoit Gallery, New York, 1942; M. Knoedler and Co., New York, Memorial Exhibition, 1944

9. *The House on the Hill (The Church on the Hill)*, c. 1910
 Oil on canvas
 22 x 18
 William Arrington

 Exhibitions: The International Exhibition of Modern Art
 (Armory Show), New York, February-March, 1913;
 Kennedy Galleries (and tour), New York, May,
 1967

10. *Interior, Kitchen**
 Oil on canvas
 20 x 23¾
 Seattle Art Museum, Gift of the Estate of Anne Goldthwaite

 Exhibitions: Brummer Galleries, New York, February, 1931

11. *Near Ascain*
 Watercolor
 10½ x 12¾
 Lucy Goldthwaite

 Exhibitions: Kennedy Galleries (and tour), New York, May,
 1967

12. *North Montgomery*
 Watercolor
 14¼ x 18½
 Los Angeles County Museum of Art, Gift of David Rosen

13. *Nude*
 Oil on canvas
 30 x 24
 Robert D. Thorington

14. *The Nude**
 Oil on canvas
 22 x 18
 Montgomery Museum of Fine Arts

15. *Nude with Mantilla*
 Oil on canvas
 23¾ x 19½
 Lucy Goldthwaite

 Exhibitions: Kennedy Galleries (and tour), New York, May,
 1967

16. *On the Road to Alabama**
 Oil on canvas
 25 x 30
 Museum of Fine Arts, Boston, Gift of the Executors of the Estate
 of Anne Goldthwaite

17. *Portrait of Baby K. (The Little Fraülein or Fraulein von Knäpitsch)*
Oil on canvas
16 x 13
Montgomery Museum of Fine Arts

Exhibitions: Berlin Photographic Co., New York, 1915; Brummer Gallery, New York, 1926; Georgette Passedoit Gallery, New York, 1939; M. Knoedler and Co., New York, 1940; Kennedy Galleries (and tour), New York, May, 1967

18. *Portrait of a Young Man*
Oil on canvas
18 x 14 7/8
National Collection of Fine Arts, Gift of Richard Wallach Goldthwaite

19. *The Red Hammock*
Watercolor
11 x 13 1/2
Graham Gallery

Exhibitions: Berlin Photographic Co., New York, 1915; Kennedy Galleries (and tour), New York, May, 1967

20. *Shanty with Martin's Nest (Cabin in Alabama)*
Oil on canvas
18 1/8 x 22 1/4
National Collection of Fine Arts, Gift of Lucy Goldthwaite

21. *Showers* *
Oil on canvas
20 x 24
University of Georgia, Georgia Museum of Art, Gift of Anne Goldthwaite Estate, Courtesy of M. Knoedler & Co., Inc.

Exhibitions: 18th Annual Exhibition of New York Society of Women Artists, American British Art Center, New York, 1943

22. *Spanish Señorita,* c. 1912*
Oil on canvas
18 x 15
Mr. and Mrs. John H. Neill

23. *Still Life—Mimosa*
Oil on canvas
22 1/4 x 18 1/4
Mrs. Adelyn D. Breeskin

24. *Up in the Morning,* 1938
Oil on canvas
41 x 50
The Toledo Museum of Art; Gift of the Anne Goldthwaite Estate

Exhibitions: M. Knoedler and Co., New York, Memorial
Exhibition, 1944

25. *Untitled*
Oil on canvas
21 x 18
Richard Goldthwaite

26. *Venlove and Stucky Tailors* *
Oil on canvas
22 x 18
Richard Goldthwaite

27. *View of the Waterfront at Mobile (The Cotton Barge)*
Oil on canvas
30 x 60
Montgomery Museum of Fine Arts

Exhibitions: "Murals of the South," Downtown Gallery, New
York, 1935; Kennedy Galleries (and tour), New
York, May, 1967

28. *The Wagon Yard* *
Oil on canvas
25 1/4 x 30 1/2
Columbus Gallery of Fine Arts, Ohio; Gift of Anne Goldthwaite
Estate

29. *Water Hole*
Oil on canvas
25 x 30
Museum of Fine Arts, Springfield, Massachusetts, Gift of the
Estate of the Artist

Exhibitions: Macbeth Gallery, New York, March, 1938;
Georgette Passedoit Gallery, New York, 1942; M.
Knoedler and Co., New York, Memorial Exhibition,
1944

30. *Weary of Waiting on Tenth St., N.Y.*
Oil on canvas
18 x 14
Museum of The City of New York

Exhibitions: American Society of Painters, Sculptors,
Engravers, New York, April, 1939; "Life in
America," The Metropolitan Museum of Art, New
York, 1939

31. *Well*
 Oil on canvas
 23 x 21
 Graham Gallery

 Exhibitions: Kennedy Galleries (and tour), New York, May,
 1967

32. *White Mules on a Bridge* *
 Oil on canvas
 24 7/8 x 30
 The Metropolitan Museum of Art

 Exhibitions: M. Knoedler and Co., New York, Memorial
 Exhibition, 1944

33. *Young Mother* *
 Oil on canvas
 30 x 25
 Indianapolis Museum of Art, Gift of the Estate of Anne
 Goldthwaite

 Exhibitions: M. Knoedler and Co., New York, Memorial
 Exhibition, 1944

Selected One-Woman Exhibitions, Catalogs, and Reviews

1915 Exhibition of Paintings, Water Colors and Etchings
Berlin Photographic Company, New York

 Catalog: *Exhibition of Paintings, Water Colors and Etchings*
 Reviews: *The International Studio,* July, 1916
 New York Evening Post, October 23, 1915
 The New York Times, October 24, 1915
 The New York Times Magazine, October 24, 1915
 Art News, October, 1915
 New York Evening Sun, November 18, 1915
 Arts and Decorations, 1915

1916 Etchings by Anne Goldthwaite
Portland Art Association, Oregon

 Catalog: *Etchings by Anne Goldthwaite*

1921 Paintings and Etchings by Anne Goldthwaite
Delgado Museum, New Orleans

 Catalog: *Paintings and Etchings by Anne Goldthwaite*
 Reviews: *Art News,* March 12, 1921

Exhibition of Paintings and Etchings
Joseph Brummer Galleries, New York

 Catalog: *Exhibition of Paintings and Etchings*
 Reviews: *Arts and Decorations,* June, 1921
 The New York Times, June, 1921
 The Arts, October, 1921
 New York Herald, October, 1921
 The New York Times, November 6, 1921

1924 Paintings and Etchings by Anne Goldthwaite
Syracuse Museum of Fine Arts, New York

 Catalog: *Paintings and Etchings by Anne Goldthwaite*

1929 Anne Goldthwaite: Recent Work
Downtown Gallery, New York

 Catalog: *Anne Goldthwaite: Recent Work*
 Reviews: *The Arts,* January, 1929

1931 Anne Goldthwaite Exhibition
Joseph Brummer Galleries, New York

 Catalog: *Anne Goldthwaite Exhibition*
 Reviews: *Art News,* February 21, 1931
 The New York Times, February 21, 1931
 Art Digest, March 1, 1931
 The Arts, March, 1931
 Birmingham News, June 21, 1931

Etchings by Anne Goldthwaite
Montgomery Museum of Fine Arts, Alabama

 Reviews: *Montgomery Advertiser,* December 13, 1931

1935 Murals of the South
 Downtown Gallery, New York

 Catalog: *Murals of the South*
 Reviews: *Art News,* December 14, 1935
 New York Herald Tribune, December 15, 1935
 Art Digest, January 1, 1936
 New York Herald Tribune, January 1, 1936
 The New York Times, January 1, 1936
 Montgomery Advertiser, February 5, 1936

1937 Etchings by Anne Goldthwaite
 Montgomery Museum of Fine Arts, Alabama

 Reviews: *Montgomery Advertiser,* December 13, 1937

1938 Paintings and Water Colors
 Macbeth Gallery, New York

 Reviews: *Magazine of Art,* March, 1938
 Parnassus, March, 1938

1942 Paintings by Anne Goldthwaite
 Georgette Passedoit Gallery, New York

 Reviews: *Art Digest,* January 15, 1942
 New York Herald Tribune, January 18, 1942
 The New York Times, January 18, 1942

 Water Colors by Anne Goldthwaite
 Montgomery Museum of Fine Arts, Alabama

 Reviews: *Montgomery Advertiser,* May 12, 1942

1944 Memorial Exhibition for Anne Goldthwaite
 Knoedler Galleries, New York
 Tour: The Baltimore Museum of Art, Maryland; Carolina Art
 Association, Charleston, South Carolina; Montgomery Museum
 of Fine Arts, Alabama; Norton Gallery and School of Art, West
 Palm Beach, Florida

 Catalog: *Memorial Exhibition for Anne Goldthwaite*
 Reviews: *Art Digest,* October 15, 1944
 Art News, October 15, 1944
 The New York Times, October 24, 1944
 New York Evening Sun, October 28, 1944
 New York Herald Tribune, October 29, 1944
 Cue, October, 1944
 Baltimore Museum News, January, 1945

1945 Memorial Exhibition: Paintings, Drawings and Prints
 The Art Students League of New York

 Reviews: *The New York Times,* November 11, 1945
 Art Digest, November 15, 1945

1946 Etchings by Anne Goldthwaite
Emma Langdon Roche Gallery, Alabama

 Reviews: *Mobile Press Register,* September 15, 1946

 Etchings and Lithographs by Anne Goldthwaite
Montgomery Museum of Fine Arts, Alabama

 Reviews: *Montgomery Advertiser,* May 5, 1946

1954 Etchings by Anne Goldthwaite
Montgomery Museum of Fine Arts, Alabama

 Reviews: *Montgomery Advertiser,* March 7, 1954

1967 Oil and Watercolor Paintings by Anne Goldthwaite
Kennedy Galleries, New York
Tour: Mobile Art Gallery, Alabama; Montgomery Museum of
Fine Arts, Alabama; Columbus Museum of Arts and Crafts,
Georgia

 Catalog: *Oil and Watercolor Paintings by Anne Goldthwaite*
 Reviews: *Mobile Register,* July 2, 1967
 Art News, Summer, 1967
 Montgomery Advertiser, September 7, 1967
 Montgomery Advertiser, September 16, 1967

Selected Group Exhibitions, Catalogs, and Reviews

1913 Exhibition of Modern American Painters
The Macdowell Club of New York

 Reviews: *The New York Times,* November 2, 1913

1923 American Contemporary Artists
St. Mark's in-the-Bouwerie, New York

 Catalog: *American Contemporary Artists*

1926 Exhibition of Etchings
The Milch Galleries, New York
Tour: Memphis, Tennessee; Dayton, Ohio; Ft. Wayne, Indiana

 Catalog: *Exhibition of Etchings: Margery Ryerson, Anne
 Goldthwaite and Loren Barton*
 Reviews: *Art News,* January 16, 1926

1928 Exposition de la Gravure Moderne Americaine
Bibliothèque Nationale, Paris

Catalog: *Exposition de la Gravure Moderne Americaine*

An Exhibition of Work by Walter Shirlaw and His Pupils
Brooklyn Museum, New York

Reviews: *Art News,* December 28, 1928

1929 New York Society of Women Painters Fourth Annual
Anderson Galleries, New York

Reviews: *The Brooklyn Eagle,* February, 1929
New York Evening Post, February, 1929
New York Herald Tribune, February, 1929
Art Digest, March 1, 1929

Etchings by Anne Goldthwaite and Eugene Higgins
Women's City Club, New York

Catalog: *Etchings by Anne Goldthwaite and Eugene Higgins*
Reviews: *New York Herald,* February 10, 1929

1932 Group Exhibition
National Arts Club, New York

Catalog: *Group Exhibition*
Reviews: *The New York Times,* November, 1932

1933 Contemporary Works by American Artists
Downtown Gallery, New York

Reviews: *The New York Times,* October 26, 1933

1943 138th Annual Exhibition of Oils and Sculpture
Pennsylvania Academy of The Fine Arts, Philadelphia

Reviews: *Montgomery Advertiser,* February 11, 1943

18th Annual Exhibition of New York Society of Women Artists
American British Art Center, New York

Reviews: *Art Digest,* March 15, 1943

Public Collections

Addison Gallery of American Art
Andover, Massachusetts

The Art Institute of Chicago
Chicago, Illinois

The Baltimore Museum of Art
Baltimore, Maryland

The Brooklyn Museum
Brooklyn, New York

Carnegie Institute
Pittsburgh, Pennsylvania

Cleveland Museum of Art
Cleveland, Ohio

Columbus Gallery of Fine Arts
Columbus, Ohio

The Detroit Institute of Arts
Detroit, Michigan

Fine Arts Gallery of San Diego
San Diego, California

The Fine Arts Museums of San Francisco
M. H. de Young Memorial Museum
San Francisco, California

Fogg Art Museum
Harvard University
Cambridge, Massachusetts

The University of Georgia
Georgia Museum of Art
Athens, Georgia

The High Museum of Art
Atlanta, Georgia

Honolulu Academy of Arts
Honolulu, Hawaii

Indianapolis Museum of Art
Indianapolis, Indiana

J. B. Speed Art Museum
Louisville, Kentucky

Los Angeles County Museum of Art
Los Angeles, California

The Metropolitan Museum of Art
New York, New York

The Minneapolis Institute of Arts
Minneapolis, Minnesota

Montgomery Museum of Fine Arts
Montgomery, Alabama

Museum of Art
Rhode Island School of Design
Providence, Rhode Island

Museum of The City of New York
New York, New York

Museum of Fine Arts
Boston, Massachusetts

Museum of Fine Arts
Springfield, Massachusetts

The Museum of Modern Art
New York, New York

National Collection of Fine Arts
Washington, D.C.

The Newark Museum
Newark, New Jersey

Philadelphia Museum of Art
Philadelphia, Pennsylvania

The St. Louis Art Museum
St. Louis, Missouri

Seattle Art Museum
Seattle, Washington

The Toledo Museum of Art
Toledo, Ohio

Virginia Museum of Fine Arts
Richmond, Virginia

Wadsworth Atheneum
Hartford, Connecticut

Whitney Museum of American Art
New York, New York

The William Hayes Ackland Memorial Art Center
The University of North Carolina
Chapel Hill, North Carolina

Williams College Museum of Art
Williamstown, Massachusetts

Worcester Art Museum
Worcester, Massachusetts

Yale University Art Gallery
New Haven, Connecticut